Insta-glam

Hani Sidow

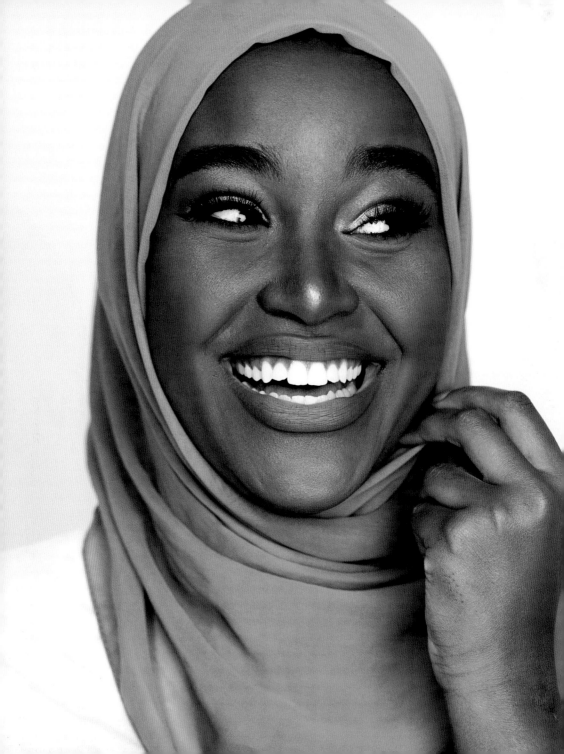

Your make-up guide to get Instagram® ready

Insta-glam

Hani Sidow

Photography by Claire Pepper

Kyle Books

An Hachette UK Company
www.hachette.co.uk

First published in Great Britain in 2019 by
Kyle Books, an imprint of Kyle Cathie Ltd
Carmelite House
50 Victoria Embankment
London EC4Y 0DZ
www.kylebooks.co.uk

ISBN: 978 0 85783 655 7

Distributed in the US by Hachette Book Group, 1290 Avenue of the Americas,
4th and 5th Floors, New York, NY 10104

Distributed in Canada by Canadian Manda Group, 664 Annette St., Toronto,
Ontario, Canada M6S 2C8

Publisher: Joanna Copestick
Editor: Vicky Orchard
Design: nic&lou
Photography: Claire Pepper
Make-up artist: Hani Sidow
Production: Lucy Carter

A Cataloguing in Publication record for this title is available from the British Library

Printed and bound in China

10 9 8 7 6 5 4 3 2 1

Contents

Introduction

Acknowledgements

Introduction

Hey everyone, welcome to Insta-glam. I hope this book will become your go-to for any occasion you need to get glam for! I remember coming to the UK in 2003 with absolutely no idea of what I wanted to achieve in life, but I had dreams. If you told me then that I would be the author of a book one day, I probably would have laughed, but dreams really do come true.

I wasn't exposed to a lot of make-up while growing up; you could say I was a late bloomer. I always watched a lot of YouTube videos, in particular tutorials by Jayde Pierce and Huda Beauty, who were a big part of my beauty journey. However, it was only during my first year of university that I got into applying make-up myself. My best friend Marni and I would spend days doing our make-up, just to take pictures, so I started my Instagram account in 2015 and began sharing my make-up pictures. Marni had a lot of faith in me and always helped me with getting content for my Instagram by sharing the latest trends with me and taking my pictures for me.

This was just the beginning. It all got serious and real when my sisters bought me a professional camera and a lighting kit for my birthday and that's when I had an idea of where I wanted this journey to head. When I began my Instagram account, there were not many people that I could identify with in the beauty industry so when I began writing my Glam Hijabi column in Glamour UK magazine, I was thrilled to be a voice for the minority and an inspiration to young

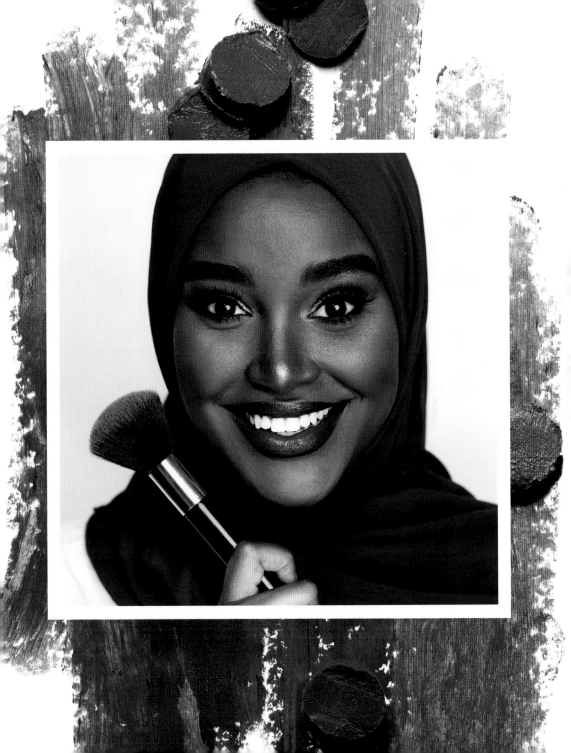

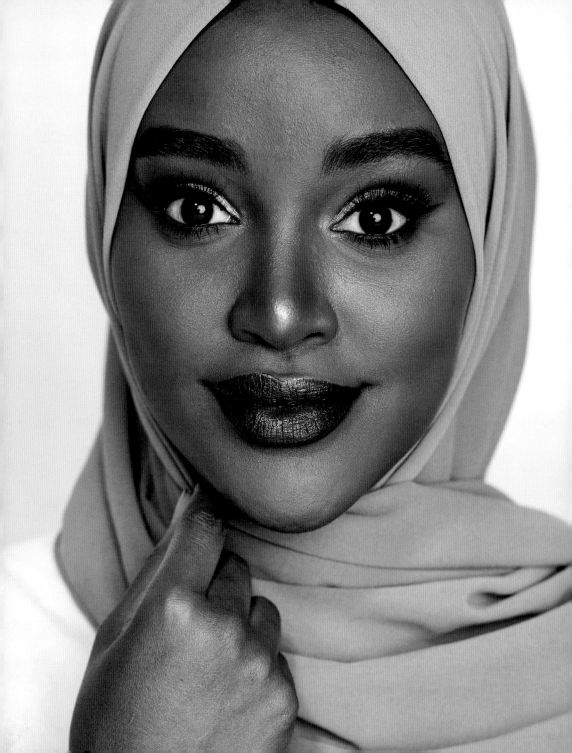

girls to remind them that the hijab is not a barrier but rather a shield. I also wanted to show them how powerful it is.

I'd love for this book to be your beauty dictionary for everything glam; a collection of all the things I wanted to know when I was learning how to do make-up myself. It can be frustrating following videos, so I hope the step by steps in this book allow you to grasp everything at your own pace. I want you to have fun for every occasion and try things that you wouldn't normally try.

Make-up has personally helped enhance my confidence because I was able to learn everything myself. Knowing that I taught myself really did wonders for me and now I know I am capable of accomplishing anything. I use make-up because I enjoy it. I love showing my art on my face as it allows me to be the best version of myself, both physically and mentally.

Remember that the use of make-up won't change your natural beauty, but I would say it can be an enhancement of what our mommas gave us, so don't be afraid to be experimental, play with it and perfect your amazing Instagram selfies!

Love Hani xo

The Looks

01\

Flawless foundation

Finding the perfect foundation can be a really daunting experience. From getting the correct colour match, to the right finish and immaculate coverage, it can feel as though it is almost impossible to find your dream foundation. I know I have always struggled with finding my shade because my skin is that awkward in-between colour. For a very lucky few, the experience is quick and easy and they can find what they are looking for without any fuss. But if you are one of the majority still struggling to find the right foundation for you, here are a few tips that will help to make the experience a little more enjoyable. Finding the perfect foundation with exactly the criteria you have been looking for is so rewarding, so don't give up on the process. Keep trying out different brands, finishes and tones, and see what works for you. Remember, everyone is unique and just because your twin sister has oily skin with a warm undertone, it doesn't mean that you will have the same.

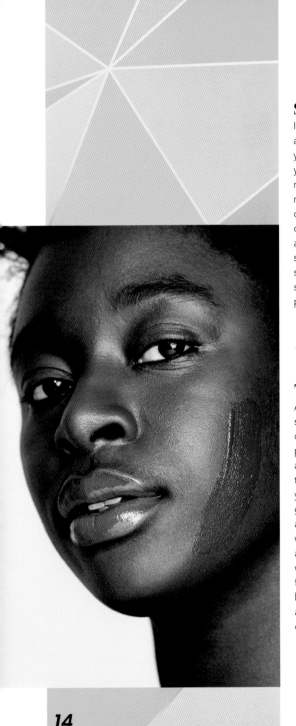

Shade

It is super-important to know whether your skin has a cool, warm or neutral undertone. The last thing you want is that harsh colour contrast between your jaw, where your foundation stops, and your neck, so I would advise asking a specialist on a make-up counter to try out three or four shades on your jawline or neck to see which one is the closest match to your skin. A big mistake is to test a colour on the back of your hand. As easy as this seems and as much as you think your hand is the same colour as your face, it is not. Knowing your shade is the biggest step towards ensuring the perfect foundation.

Texture

All my life I have had really dry cheeks and a super-oily T-Zone. As much as I tried all kinds of skincare products, I still struggled to get that perfect oil balance in my face, so I compromised and worked on finding the best foundation texture to complement my skin. Based on how you want your skin to look, try different foundations that give you a finish you like. So, if you have oily skin and don't want to look too greasy but also don't want a very matte finish, don't be afraid to try out a dewy foundation. There are literally no rules when it comes to this so have fun trying different finishes and see what works best. Don't be hesitant to add other steps to your routine, such as primer under your foundation or setting powder on top of it, to get the right finish for you.

Coverage

Whether you love a full or subtle foundation, it can be difficult to achieve that perfect coverage without feeling like a "cake face". I have always loved a full, flawless face as part of my everyday routine, but of course, like most people, I absolutely hate that heavy sensation and still want to feel like I am wearing very little on my skin. When you try different foundations, remember that thickness DOES NOT mean full coverage. Sometimes I find myself using the most lightweight foundation and getting all the coverage I need from a few pumps, and that is pretty satisfying.

02\ *Highlight and contour*

For years, many professional make-up artists have highlighted and contoured their clients' faces but it is only recently that highlighting and contouring has become a social media trend, with everyone posting images of their face made up with different shades of concealer. I remember the first time I discovered the power of highlighting and contouring; it was after seeing an image of Kim Kardashian circulating online. I recall her cheekbones and jawline being so much more defined than usual. I didn't know how she had achieved that look but I knew I wanted it. It felt like I had finally got the cheat sheet on flawless make-up once this became a beauty craze. After binge-watching thousands of tutorials on YouTube, I became my own expert and implemented the technique as if I had been born to do it. Here is how I like to highlight and contour when working on both clients and myself.

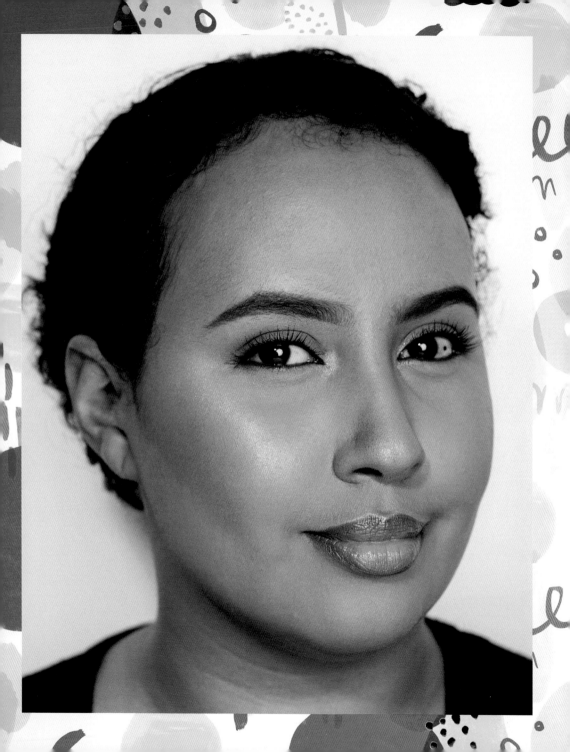

HOW TO...highlight and contour

1.

Highlighting and contouring is fairly full-on make-up, so I recommend that you prep your skin beforehand to ensure your look is as flawless and long-lasting as possible. I begin by using my favourite serum, moisturizer and SPF 50 sunscreen. That's right, sunscreen! This is a product we all sometimes ignore when it comes to wearing make-up, as we assume our make-up itself will protect us from sun damage, but it definitely will not. Once your skincare products have soaked into your skin, go in with your primer to ensure your make-up has a perfect base and lasts all day long.

2.

For me, colour correcting is an important part of every face routine. I like to make sure that before I apply my foundation I have corrected any discolouration that could, possibly, change its tone. Not everyone needs a colour corrector in their routine, but I definitely feel it helps my under-eye circles appear less ashy after I apply my foundation. If you are a little confused about what all those coloured concealers you have seen all over Instagram are for, here is a little breakdown:

- *Orange* – Helps to conceal dark spots, under-eye circles and any hyperpigmentation around your face.

- *Green* – Perfect for covering any redness, including rosacea and those stubborn little red spots.

- *Purple* – Best used for correcting yellow bruises and sallow skin tones, and amazing for brightening up a dull complexion.

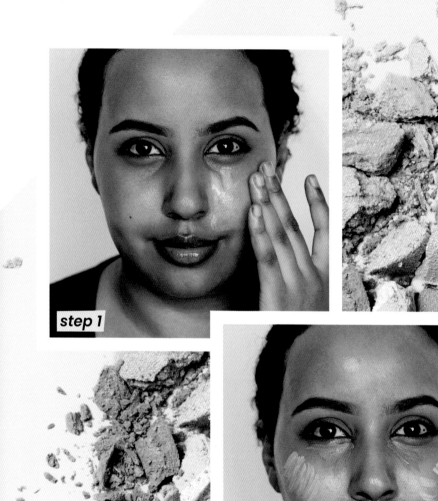

step 1

step 2

insta-glam

19

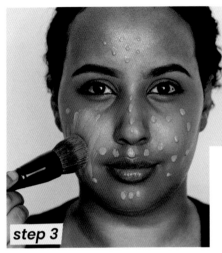

step 3

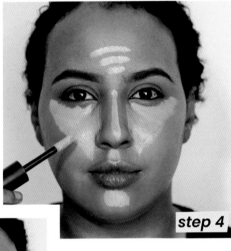

step 4

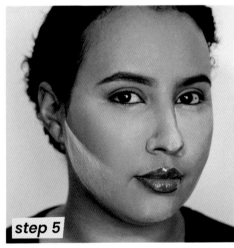

step 5

3.

It is now time to apply your chosen foundation. When it comes to foundations, I love a dewy and lightweight finish so that my skin doesn't feel too heavy after I have added all my other products. I like to begin by dotting my foundation around my face using my finger and then going in with a stippling brush for extra precision. Because I will be applying more products to my face, it is essential to have a well-blended base, so next I use a damp make-up sponge to give me a completely flawless finish.

4.

Now for the part you have been waiting for! It is time to apply your concealer to the areas of your face that you want to bring forward. This is different for everyone, depending on the shape of your face and which areas you would like to enhance. What I find often works for most people when it comes to highlighting is to apply a lighter coloured concealer under the eyes in an upside-down triangle and also a little to the middle of your nose, in between your eyebrows and on your chin. If you have a deeper complexion, I recommend choosing a concealer that has a warm tone but is still a few shades lighter than your skin tone because that will really help to keep your under-eye area bright. If your skin is a little fairer, a slightly pink- or neutral-toned concealer will ensure it looks healthy and radiant.

5.

Make sure your concealer is evenly blended out, using your beauty blender, and then set with a translucent powder, banana powder or pink-toned powder, depending on your skin's complexion. I find that on my deeply-toned skin a yellow-tinted powder really helps to give me that perfect highlight, especially under my eyes. When I work on other complexions that are lighter and fairer, I find that a pink-toned powder really gives that sought-after brightness under the eyes.

6.

After all that highlighting, the skin can appear a little ghostly, so it is important to add warmth back into your complexion. I suggest doing this by using a fluffy powder brush packed with a pressed powder in your natural skin tone. Now that your face is perfectly highlighted and looking flawless, it is time to contour. I always prefer a powder to a cream finish for contouring because it is easy to blend out and gives a more seamless finish. I lightly apply a dark bronzer under my cheekbones and jawline, on the sides of my nose and on my temples. When it comes to shades of bronzer, I recommend a cool tone for fairer complexions, a neutral tone for medium skin tones and a deep, rich tone for darker complexions.

7.

The fun part is adding a touch of blusher for some colour directly above the bronzer on your cheekbones. A seamless and simple way to tie all your make-up together would be to brush the same blusher lightly over your eyelids and on your lips. For a golden finish, add a shimmery gold or bronze colour to the highest points of your cheekbones, down the middle of your nose and on the Cupid's bow of your lips. I love a bronze colour on my complexion but I recommend a golden highlighter for medium skin tones and a silvery one for fairer complexions.

Hani says

Highlighting and contouring can give a really full-on look but that doesn't mean you can't improvise and switch things around to suit your lifestyle. You might not have the time to do this in the morning before work or for a night out, so it is important to play around, have fun with it, see what works for you and customize it to your taste.

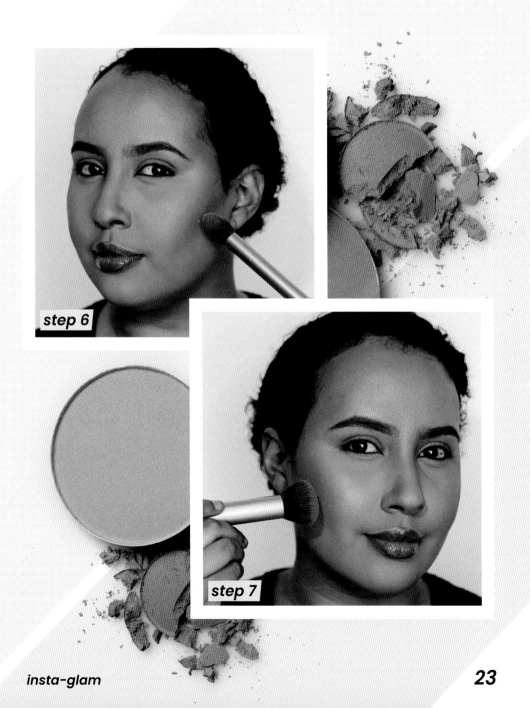

step 6

step 7

For perfect highlight and contouring, you will need...

- serum

- moisturizer

- SPF50 sunscreen

- colour corrector

- foundation

- concealer

- powder

- bronzer

- blusher

03 \ *Beautiful blush*

For so many years, blusher has been the big secret to radiant and fresh-looking skin. Since the craze for highlighting and contouring, however, it has been slightly pushed to the back of our minds and we have forgotten the power of good blush. If you are after a look that says, "I have been going to the gym all my life and eating my greens every day," then blusher is the answer. But finding that sophisticated flush that doesn't make you look awkwardly pink can be a little daunting. I firmly believe blusher should be a staple in everyone's make-up bag, so let me help you find the right formula and texture for your cheeks.

\ *What colour blusher is best for me?*

Once you have found the right formula (see page 29), the next step is to find the right shade. You may be surprised to know that your blusher does NOT have to be pink and, actually, there is no "right" shade. A lot of people say that you should go for the colour that most resembles your natural flush but, as much as this makes sense, it is not always the case. When it comes to picking a shade, I think the best way is to experiment with all the different colours and see which one you like the most. I sometimes find myself wearing purple blusher because I love how it gives my complexion a hint of colour with a subtle shadow. But this doesn't stop me from wearing the light peachy tones and the bright oranges and pinks. Think of it this way: with a light hand, you can wear almost any colour because all blushers are buildable and you can keep adding more until you get your desired effect. There is no right or wrong.

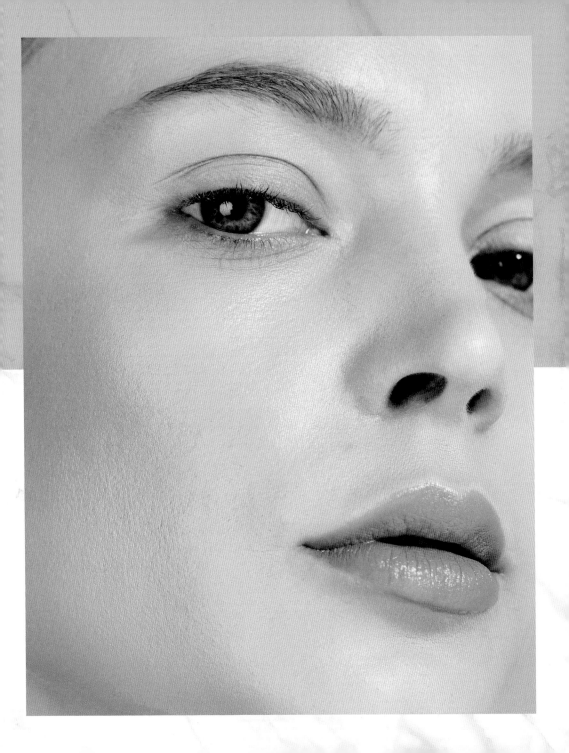

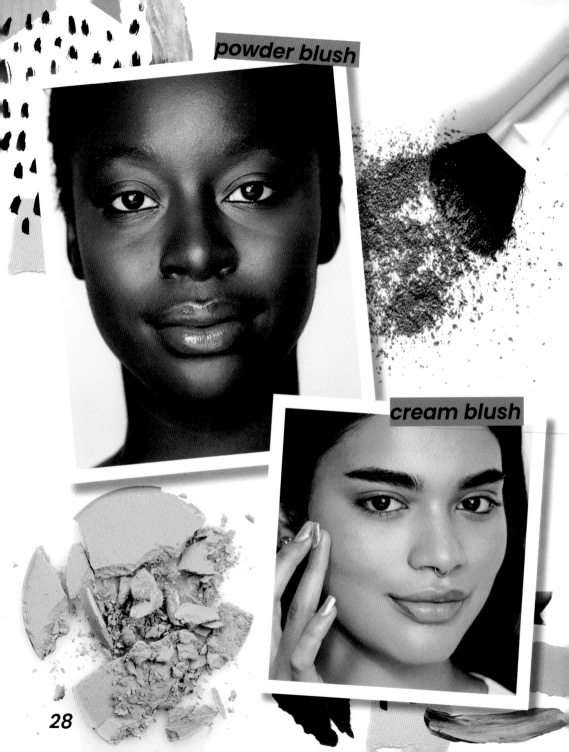

powder blush

cream blush

28

The three most common forms of blush are cream blush, powder blush and cheek stain. Each formula works differently, depending on your skin type, so try them all to see which one works best for you. Even if it doesn't work for your cheeks, blusher is one of those will-work-on-anywhere products – creams and stains can be dabbed onto lips, while powder and creams can be used as eyeshadows.

01 Cream blush:

I remember my first ever lipstick, which I bought for my high school graduation. It was this incredible maroon colour that I literally used for everything: I applied it on my cheeks as blush using my fingers and on my eyelids as eyeshadow. So when this lipstick was discontinued, I was horrified. I tried to find a blusher and an eyeshadow in that exact shade and it was not an easy journey. Then I realized that, actually, it was not the tone of the lipstick I liked but its formula and the glow it gave to my skin. So I tried a series of cream blushers. At the time, I barely wore make-up, so the cream blush was perfect for my natural make-up looks. It blended out to a really moisturizing finish and my dry skin loved all the hydration it was getting in the process.

02 Powder blush:

This is perfect for everyday wear. Being the lazy 22-year-old that I have become means I sometimes don't have the time or energy to blend out a cream blusher, so sweeping a powder blusher on quickly with a fluffy brush when I am in a rush does the trick for me. My favourite thing about powder blush is that it is very buildable and you can easily intensify the colour and dial it up for a more dramatic evening look. Sometimes, when I am feeling adventurous, I love applying a cream blusher and then lightly dusting a powder blush on top for extra-long-lasting colour all day.

03 Cheek stain:

I always find cheek stain amazing for "no make-up" make-up days, when you just want to add a touch of colour to your skin. It lasts practically forever and a little bit goes a long way. Another great thing about cheek stain is that it also works on your lips. I recommend a cheek stain for those who wear minimal make-up because it can be too subtle as part of a more glam look. Final tip: you have got to blend a cheek stain quickly before it dries and you are left with dots of stain, which won't be cute.

For beautiful blush, you will need...

- cream blush

- powder blush

- fluffy brush

- cheek stain

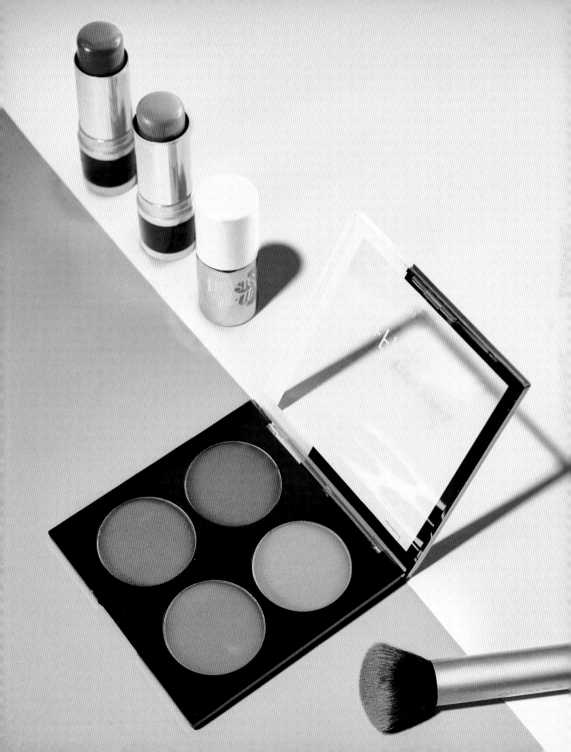

04\ *Insta-brows*

Finding the perfect foundation and nailing highlighting and contouring is one thing, but mastering all the social media trends and actually being able to keep up – you deserve a medal for that one! The battle between the natural brow and the Instagram brow has been trending on social media for a while now but I think the trend for strong, defined brows won't be ending anytime soon. Since my eyebrows are naturally quite thick, I absolutely love this trend.

The best thing about it is that you can make your eyebrows as bold and as defined as you want. You can use products that give a slightly softer touch for more natural Insta-brows or go full force for a dramatic look. Here are some guidelines on how to get impeccable eyebrows, followed by a step-by-step guide for achieving perfect "Insta-brows".

Grooming:

If you don't give a plant the nourishment it needs every day, how do you expect it to grow? Use this same concept when it comes to your eyebrows. In the same way as you brush your hair every day, brush your eyebrows, too. Massaging some coconut oil or eyebrow growth serum into your brows really helps to stimulate those hair follicles and enhance growth. Once your eyebrows are healthy and full, shaping them will cut the styling time in half.

Finding the correct product:

Eyebrow pencils are not made for everyone. I recommend using a pencil only if you have really sparse brows, as it is perfect for imitating hair-like strokes. A powder works best for brow hair that is already full because you will be able to just lightly fill in the areas you need to without looking too overpowering. If you are after a really defined and dramatic look, a gel works wonders since it contains a lot of pigment to add depth to your brow colour and it also lasts a really long time.

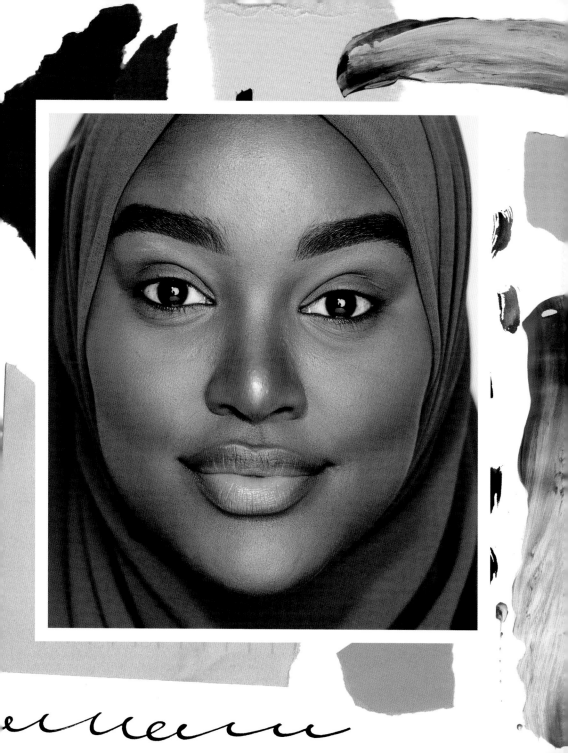

HOW TO...get perfect insta-brows

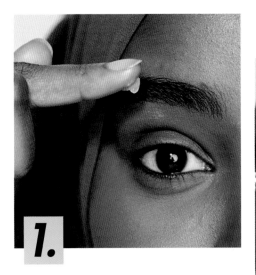

1.

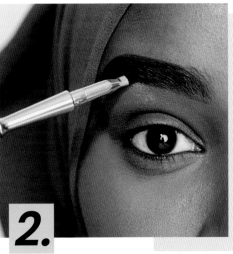

2.

Begin by using a spoolie to brush your eyebrow hairs in the same direction. This will allow you to see the areas you need to fill and those that need fewer products. (It is important to brush your eyebrows after every step because this will ensure all the products are well blended so there is no harshness to the end result.) It is optional to then go in with an eyebrow primer to condition and nourish your brows while prepping them for any products you are about to apply.

I suggest you then outline the natural shape of your eyebrows, extending the length at both ends, depending on the shape of your face and your natural brows. Once you have outlined the desired shape, fill in any sparse areas using fine, hair-like strokes, working from the beginning of each brow to its outer corner. For a bolder look, go in with a powder at the arch and fill it in slightly darker, without forgetting to give it a final brush through to blend everything together.

insta-glam

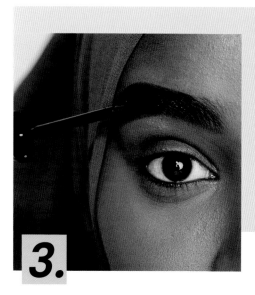

3.

To keep my eyebrows neatly in place all day and for a long-lasting finish, I like to brush them through with an eyebrow-setting gel. This acts in pretty much the same way as hairspray and will keep any unruly eyebrow hairs under control.

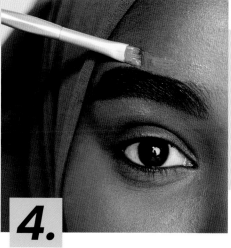

4.

tip

Keep in mind the eyebrow proverb you've probably heard many times: your eyebrows are not twins, they are sisters. Don't stress yourself trying to make them identical because even the most perfect Insta-brows are not symmetrical.

The final step, which automatically takes your eyebrows from natural to Instagram slay, simply requires concealer. Use one that is a bit lighter than your skin colour to highlight underneath your eyebrows with an angled brush. This acts as a cover-up for any hairs you have not plucked and gives the brows a perfect, even shape. To avoid your eyebrows having that halo look, I suggest using a touch of your foundation, in a shade that closely matches your skin, to clean up the top of the brows. For that extra push, go in with a little shimmery highlighter underneath your brow bone to really define your arch, or, as I do, to fake an arch.

For insta-brows, you will need...

- spoolie brush
- eyebrow primer
- eyebrow pencil
- eyebrow gel
- shimmery highlight
- eyebrow shadow
- concealer
- foundation

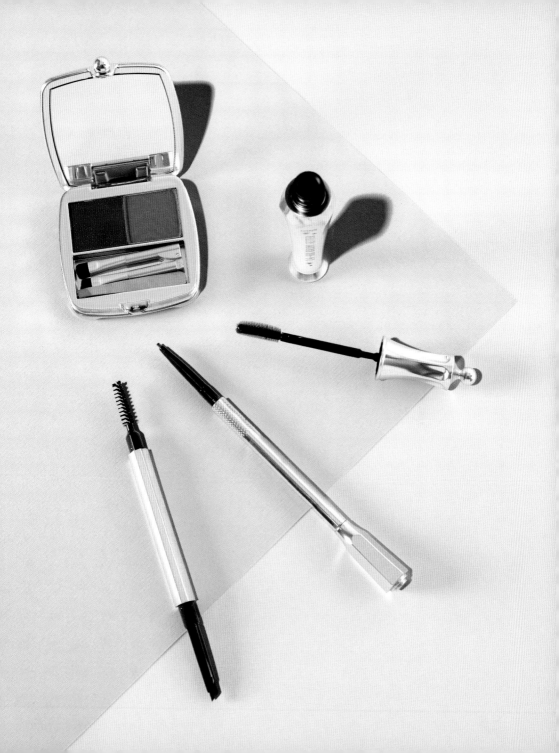

05\

Smoky eye

I think it is safe to say that we have all been trying to nail a classic smoky eye since forever. The process of getting it right can be a little excruciating because if it is not done well you can easily end up with panda eyes. But, when it comes to eye make-up, a smoky eye is everyone's go-to for any party or special occasion, so it is important that you get this one in the bag so you are prepared for any big events you have coming up.

Here is a breakdown of how to master the smoky eye in six easy steps. Don't let the word "smoky" scare you – it doesn't mean a black eyeshadow all over your eyelid; you can use this technique with any colour of your choice to complement your skin tone and eye colour.

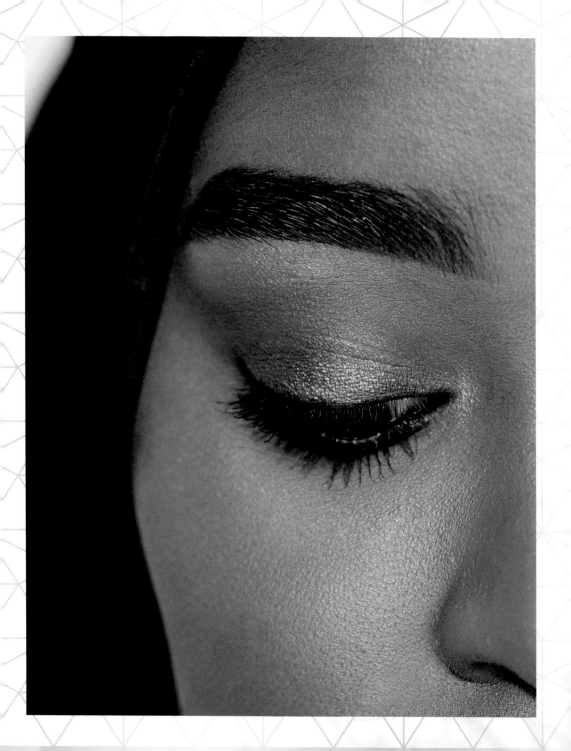

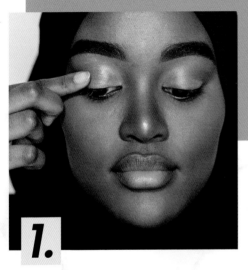

HOW TO...get the perfect smoky eye

1.

I am sure by now you have learned that prepping and priming are pretty much the first steps for everything. So take your eyeshadow primer and gently apply it all over your eyelid and slightly under your eye as well. Nobody likes it when their eyeshadow creases, sets into a line or smudges, so this step will really help to keep any products that you apply locked in place.

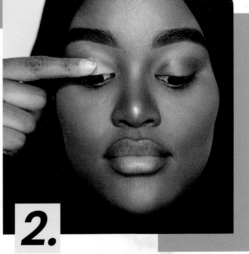

2.

To neutralize any discolouration, I suggest applying your concealer all over your eye area. Sometimes dark circles can make a smoky eye look just like a bruise and completely change this look from sexy to scary really quickly. I recommend using a creaseless concealer to ensure that your primer stays effective.

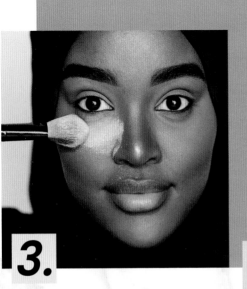

tip

Applying loose powder under your eye will help catch all the fallouts from the eyeshadow.

3.

Set your concealer using loose or pressed translucent powder to keep it in place and make your blank canvas ready. Applying a little translucent powder with a fluffy brush directly underneath the eyes is the secret to a make-up artist's flawless finish. As well as helping to brighten the under-eye area, the powder under the eyes will also catch any particles of eyeshadow that fall down onto the face when you apply it. Before I discovered this trick, I always did my eye make-up first and then my face, because otherwise there was always the risk of ruining the make-up on my face.

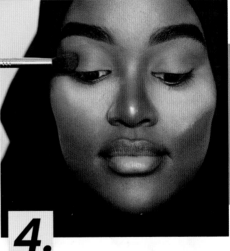

4.

It is now time to get those colours in and begin applying your eyeshadow. When it comes to a smoky eye, the ultimate secret is just thorough blending. It is a transition from light to dark, so I suggest beginning with your lightest colour, preferably a really light and warm-toned brown and applying it just above your crease. Use a fluffy brush to blend this out until you are satisfied with the effect.

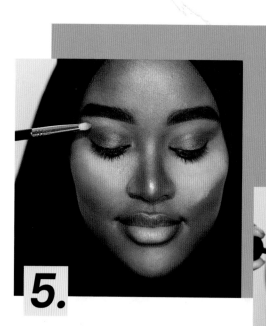

5.

Take a colour that is slightly darker and apply it directly into the crease, ensuring that you blend both colours together. Once this is done, apply the base colour all over your eyelid, preferably using your finger. Then take a clean fluffy brush and blend it into your crease. Apply the same colours that you used on your upper eyelid to your lower lash line and make sure that they are all blended together.

For extra drama, add some eyeliner to your lash line. I love using a kohl pencil liner directly on my lash line and then smudging it out using an angled brush. The brush helps you to drag the liner slightly outwards, to give you a wing that is not too harsh and blends into your eyeshadow. You can also apply this eyeliner to your waterline and blend it along your lower lash line for a more smoky effect all around your eye.

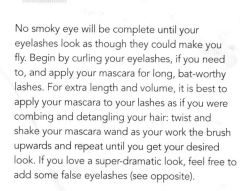

6.

No smoky eye will be complete until your eyelashes look as though they could make you fly. Begin by curling your eyelashes, if you need to, and apply your mascara for long, bat-worthy lashes. For extra length and volume, it is best to apply your mascara to your lashes as if you were combing and detangling your hair: twist and shake your mascara wand as your work the brush upwards and repeat until you get your desired look. If you love a super-dramatic look, feel free to add some false eyelashes (see opposite).

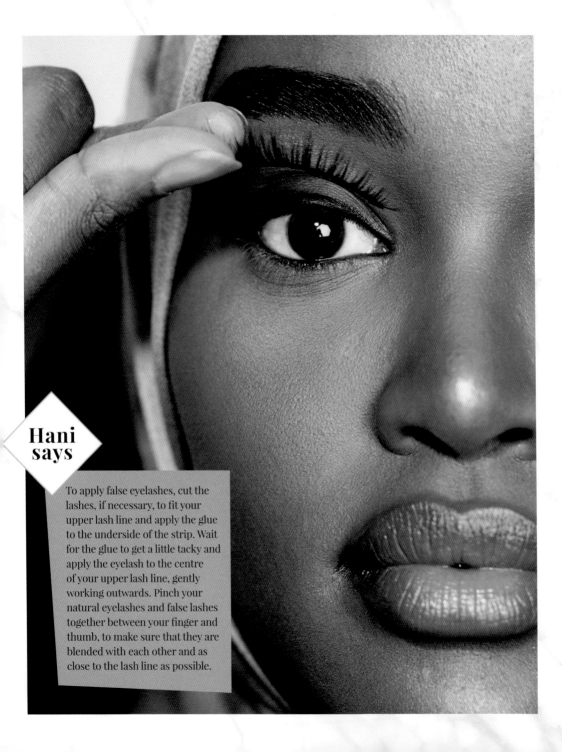

Hani says

To apply false eyelashes, cut the lashes, if necessary, to fit your upper lash line and apply the glue to the underside of the strip. Wait for the glue to get a little tacky and apply the eyelash to the centre of your upper lash line, gently working outwards. Pinch your natural eyelashes and false lashes together between your finger and thumb, to make sure that they are blended with each other and as close to the lash line as possible.

For smoky eyes, you will need...

- eyeshadow primer
- concealer
- translucent powder
- eyeshadow
- eyeliner
- mascara
- false eyelashes

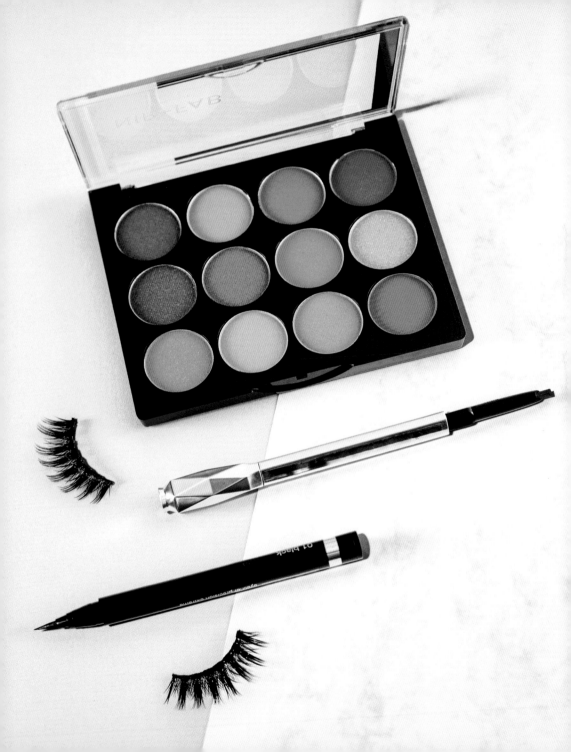

06\ Perfect winged liner

Some days you might surprise yourself at how amazing and sharp the wing you create is and other days you might question how on earth you ended up making a mess of something that so many YouTube gurus do with their eyes pretty much shut. Don't give up. Everyone has a different eye shape and success is all about finding out what eyeliner works best for you; then, inevitably, practice makes perfect.

It is important you have an eyeliner that you can master to give you the results you want. Here is a breakdown of the different types of eyeliner so you can work out which one best caters to your needs and capabilities.

01 Liquid liner
This can be a messy one, especially if your hand shakes like mine. Liquid eyeliner is amazing for giving a sharp and precise winged line, though, so I definitely recommend it if you are great at controlling your hand movements.

02 Kohl pencil eyeliner
Although this is mostly used for tightlining the eye – that is, lining the waterline and in between the roots of the lashes for subtle definition – some people actually achieve amazing results by doing their winged liner using a kohl pencil. Personally, I am still learning how, but this is a great product for those who like a more smudged-out, smoky look.

03 Gel liner
This is for those who love a bold look. It can be a little tricky, as you have to use an angled brush with great precision to create the flick. This is possibly the best eyeliner for a full-on glam eye that is intense and rich in colour, and I would also rank it as the most long-lasting form of eyeliner that I have tried.

04 Pen liner
If you are anything like me and love the simple stuff, then this is for you. To sum it up, this is rather like drawing your winged liner on with a pen. It is super-easy and quick but, on the downside, it can be a little difficult to use once it begins to dry out. I always find that pen liners tend to dry a lot quicker than both liquid and gel ones.

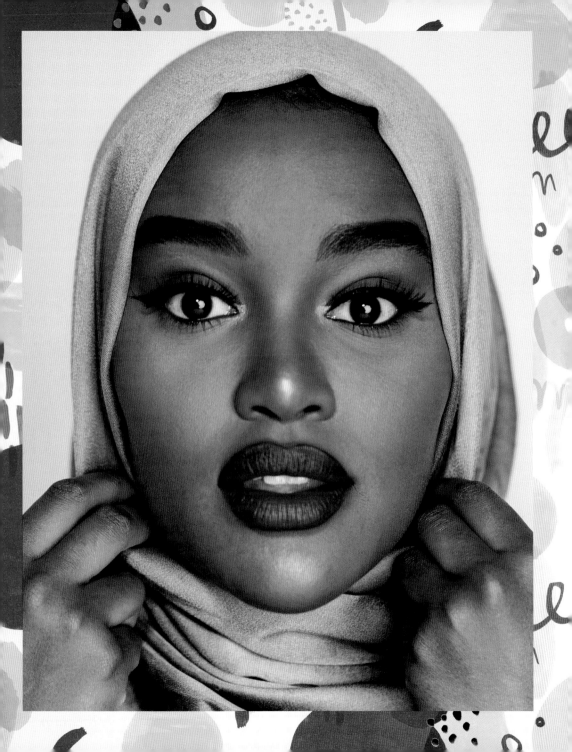

HOW TO...get the perfect winged liner

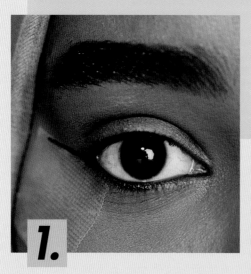

1.

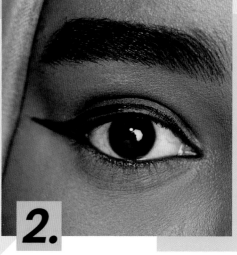

2.

As mentioned, I find pen eyeliners the easiest to use, so if this is your first time doing a winged liner, I advise you to begin with this and then work your way up. Whatever type of eyeliner you use, the steps are the same, so feel free to experiment with different liners if you wish. Begin by drawing a short line from the outer corner of the eye, angled slightly upwards, as if you are trying to connect it with the corner of your eyebrows. A little cheat that I use to practise getting a sharp line is sticky tape. I cut a little sticky tape and stick it diagonally from the corner of my lower lash line, slanting slightly up towards the end of my eyebrow. This is amazing for helping me keep my eyeliner as straight as possible.

Remove the sticky tape. Draw a line along your eyelid, close to the lash line, from the inner tear duct to the outer edge of the eye. This line doesn't need to be completely straight, so feel free to just follow the shape of your eyelid for now. It can make it a little easier if you pull your eye gently from the outer corner to flatten the skin so that the eyeliner can glide on as smoothly as possible.

tip

Make sure that you connect the first line to the rest of the liner and fill in any gaps.

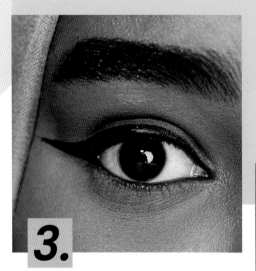

3.

Make sure that you connect the line you drew in step 1 to the rest of the liner and fill in any other gaps to ensure you have a smooth and solid line.

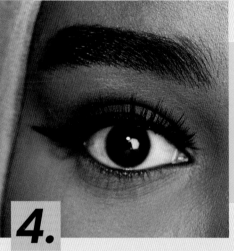

4.

Finish your perfect winged liner by adding mascara or even some false eyelashes (see page 43). Let your eyeliner speak volumes about you. Don't be afraid to make the line thinner or thicker and work with whatever suits your eye shape and your style. I think it is important to remember that make-up is a form of self-expression and there is no right or wrong way of doing things.

For perfect winged liner, you will need...

- eyeliner
- sticky tape
- mascara
- false eyelashes

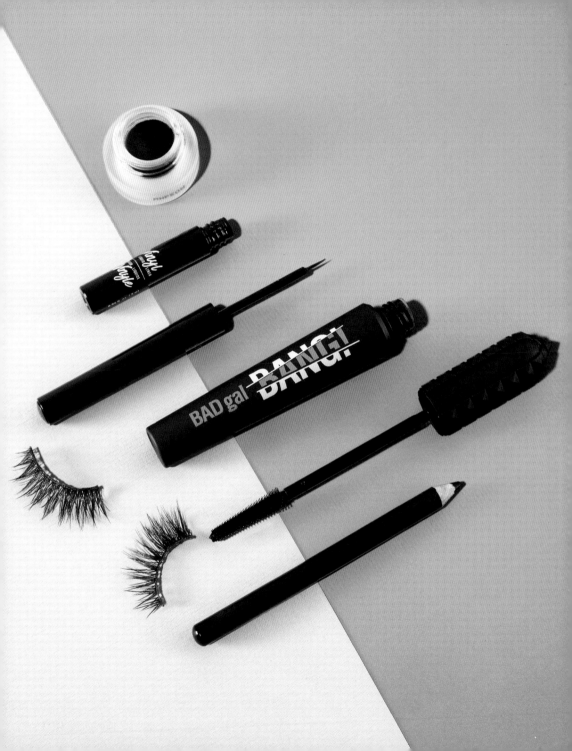

07\ Natural nude lip

When in doubt, a nude lipstick is basically the best option. It works with everything and complements almost any outfit. I always find myself purchasing the same nude-toned lipsticks and this seems to be a problem everyone else has, too, according to those I have spoken to about this. Depending on your skin tone, a variety of colours from chestnut brown to peachy pink can work as a perfect nude. Here is a guide on how to pick the tones that best flatter your complexion, plus a few tips on how to get the perfect lipstick and lip liner combo for a flattering nude lip.

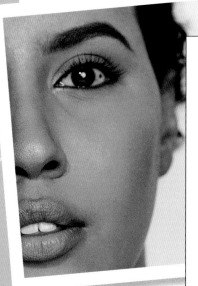

\ What "nude" is best for me?

Everyone has a different tone of lipstick that acts as the perfect nude for them, depending on their skin tone and the natural colour of their lips. My natural lips are a fairly light pink, whereas my skin complexion is quite deep, so it can be a little tricky for me when it comes to finding the perfect nude lipstick. If you have medium to dark skin, it can sometimes be a case of ignoring the nude pinks in favour of the chocolate browns. For fairer and lighter skin tones, peachy shades are often complementary because of the little pop of colour they bring.

I advise you to spend a little bit of time familiarizing yourself with your natural lip colour and trying different shades to see what works best for you. Once you have this mastered, play about with all the colours and learn how to get the most out of each of them.

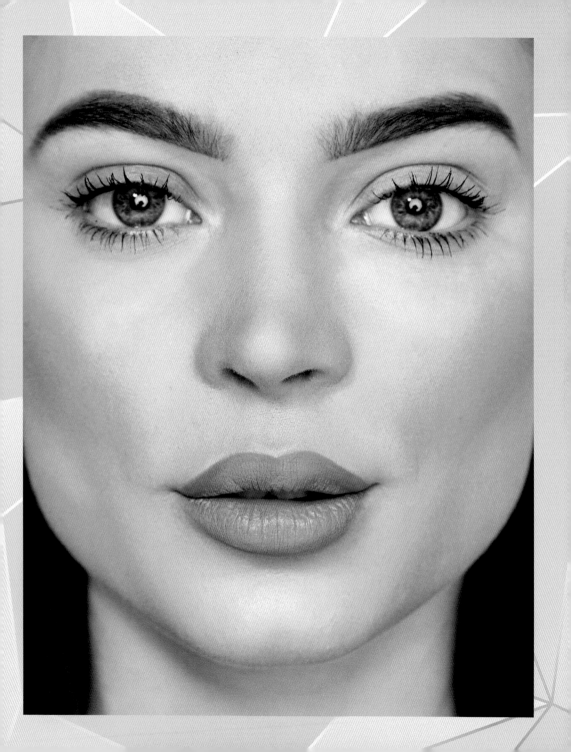

HOW TO...get the perfect nude lip

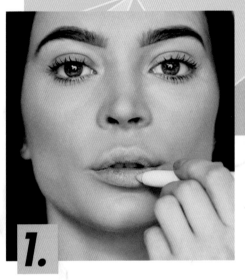

1.

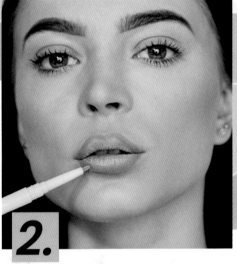

2.

I always begin any lip routine with a lip primer (see page 59). Just as you would prime your face, priming your lips is essential if you want that extra comfort and colour pay-off. I also find that priming my lips helps to prevent my lipstick from sliding. My favourite thing about lip primer is that if you have dry lips, it keeps them feeling soft and moisturized, even when you are wearing a matte lipstick.

For a lot of people, applying lip liner is a step they often skip. Sometimes I am guilty of this, too, but it was only recently that I discovered how important it is to line your lips and the difference it actually makes. Nude lipsticks can be a little hard to pull off and sometimes they don't blend nicely with your complexion unless you use a slightly darker lip liner. This is an especially common issue for those with darker skin tones. A lip liner that is a few shades darker than your lipstick works wonders when it is paired with a nude lipstick as it gives that beautiful, effortless blend.

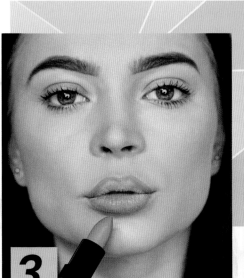

tip

Nude lip does not necessarily mean a pale pink or brown. It varies for every skin tone so make sure you give yourself options.

3.

Finish this look with your chosen nude lipstick by beginning at the centre of your lips and blending it out into your lip liner. This gives the illusion of plumper-looking lips as the lipstick acts as a highlighter in the middle of the lips and the lip liner creates a little shadow around the outer edge.

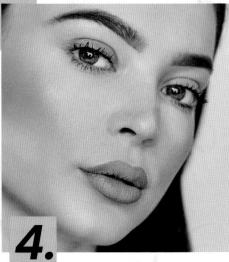

4.

Remember, it is always good to experiment and get out of your comfort zone, so don't feel as if you have to stick to one nude shade, try all kinds. Try it out with your chosen products and don't be afraid to make some changes and customize the technique to suit your lip shape, lip colour and complexion.

08\ *Brilliant bold lip*

If I were stuck on a desert island and could only have one product, it would have to be a lipstick. Not necessarily a bold colour, but anything would do, because it is such a versatile product. Having a deeper skin tone meant that for many years I stayed away from colours such as statement pinks or bright reds and always chose the same maroon shades. The boldest I ever went was a purple lipstick. But now I know how stunning those colours that I used to avoid actually look against my skin tone and I just can't stop experimenting with them. Here, you will find a guide to how to discover the best bold lip colour for you, and some great tips for making your lip colour last all day without smudging.

Bold does not just mean red lipstick, absolutely not. Any colour that stands out can be a bold lip colour. If you think a bright and bold lip is only for special occasions, then you are also wrong, because a bold lip is the perfect way to add a pop of colour to your face for both day and night. When it comes to choosing a bold lipstick, it can be tricky if you are unsure of what colour best suits your skin tone. I suggest experimenting with different tones of colours and seeing what works best for you. On the following page is list of the different tones I think are amazing for creating a bold lip look.

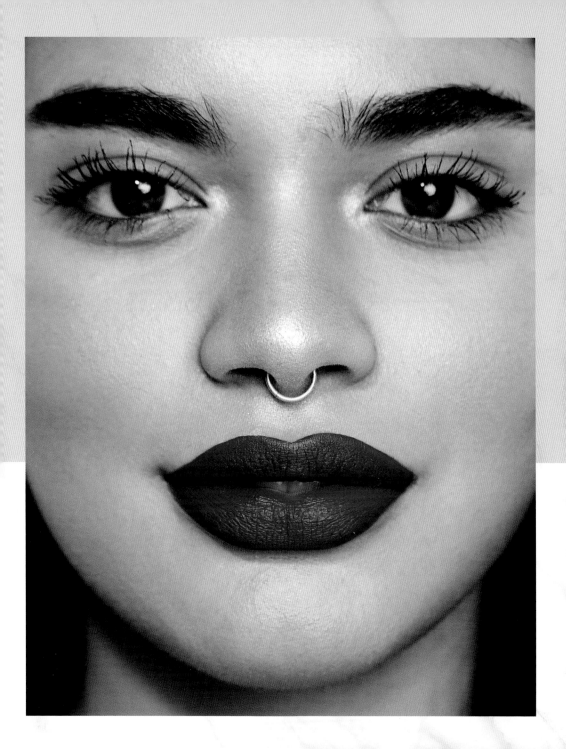

tip

Bold does NOT just mean red. Any colour that walks into a room before you could literally be classed as bold.

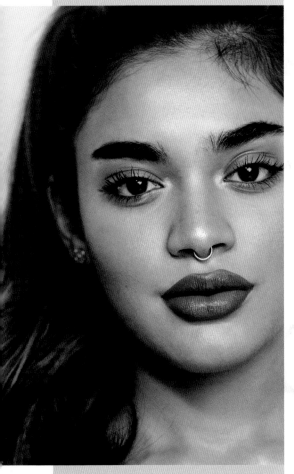

Red

This is a classic bold lip colour and the most commonly used. Red is a sultry colour that elevates your make-up game by a few levels, for sure. Although I love more orange-toned reds against my skin tone, I find that blue-toned reds look amazing on those with a lighter complexion. This is not to say that you cannot wear an orange-toned red if you are fair, or a blue-toned red if you have darker skin. Try out different tones of red until you find your favourite.

Pink

A lot of people associate this colour with Barbie and assume that a bright fuchsia pink can't be worn at certain times of the day, but who actually says you can't? I started wearing pinks before I began trying out the reds. It can be a little difficult to pull off but, once you find the right shade of pink, you will be obsessed. If you want something a little deeper, try a cool tone with more of a purple hue; if you prefer the idea of something lighter, try a peachier version (this is an especially great tone for summer).

Purple

No, purple is not a vampy colour and actually looks really nice when worn outside of Halloween. I remember the first time I tried a purple lipstick, after seeing it worn by the witch on *Trapped* (my favourite TV show at the time). It seemed such a mysterious colour and it really complemented my skin tone. Now I wear both bright and muted shades of purple and I absolutely love it.

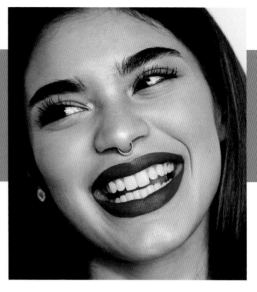

HOW TO...make your lipstick last all day

1.

Exfoliate, exfoliate and exfoliate!

In the same way as skincare is the key to a flawless base, taking care of your lips is essential for making sure your lip colour lasts as long as possible. I have always had the issue of my lips peeling naturally throughout the day, especially after I eat lunch, which can be so frustrating. When your lips begin peeling it can be discouraging to try to put on lipstick because all the flakes mean it just doesn't sit right. I find that exfoliating my lips every morning helps to keep the dead skin off for the day and makes my lipstick stay put a lot longer.

2.

Prime your lips

An essential step for making sure you get long-lasting results from your lipstick is to prime your lips. Sometimes lips can become sensitive when you wear lipstick for many hours, especially if you have dry lips. Priming your lips helps to keep them feeling comfortable and moisturized throughout the day.

You can use either a matte or a moisturizing primer. Matte primers are great for giving you plump lips and making lines on your lips less visible. I do love wearing a matte primer with a matte lipstick because it stops my lips from drying out while still keeping them matte: weird, right? However, moisturizing primers work for almost everyone. They are great for keeping your lips hydrated without giving the really glossy effect that you would get from a lip balm or some good old Vaseline. Most importantly, they give your lipstick a base to hold on to and therefore give you optimum results that last all day long.

For brilliant bold lips, you will need

- primer
- lip balm
- lip liner
- lipstick

Easy ombré lip

You will be glad to know that you can get an ombré effect on your lips as well as your hair. This creative look, where there is a subtle graduation in colour from a lighter shade in the centre of the lip to a darker one around the edges, has been circulating on social media for years. Once you have mastered the technique, the effect can be easily toned down for everyday wear or you can experiment with more adventurous looks for any occasion. All you need is a light shade of lipstick, a lip liner that is a couple of shades darker and a concealer. Yes, if you haven't got it by now, a concealer really is your best friend. I suggest experimenting with the lip colours that you already have and seeing which hues look good together. Sometimes a lighter and darker version of the same colour works really well for giving you that perfect ombré look.

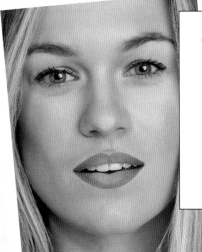

Why an ombré lip?

This is an easy way to make your make-up look extraordinary, as though you have put in the extra work, in the most effortless way possible. You can customize this look to suit you and your style so try it out with any colours you like. It can be as bold or as subtle as you wish, so I urge you to play with it, have fun and keep using it as a form of self-expression. I often dial down an ombré lip slightly for my everyday look.

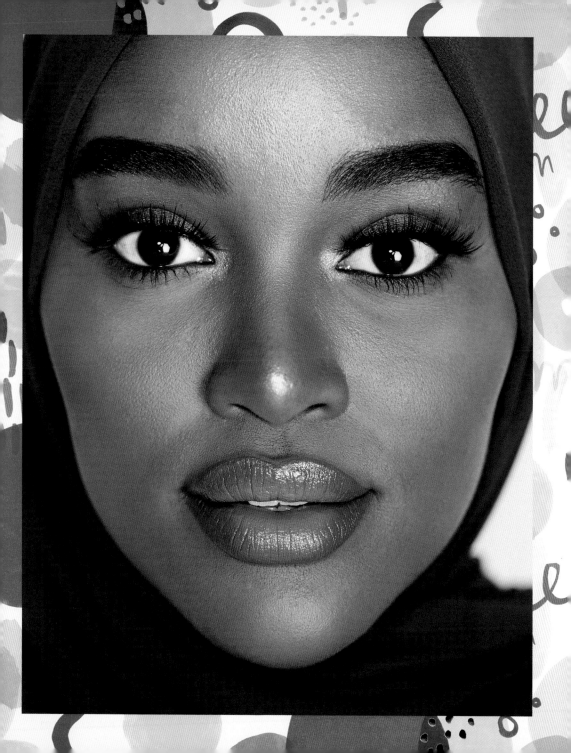

HOW TO...get the perfect ombré lip

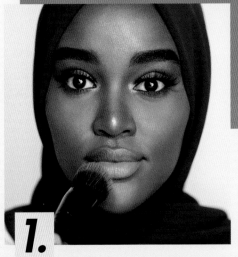

1.

Begin by applying your concealer lightly over your lips to give you a blank canvas and to neutralize your natural lip colour. This is an important step if you want to get the perfect colour pay-off from your products.

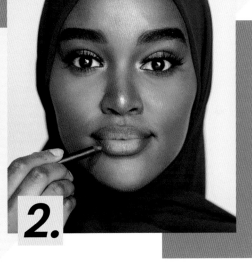

2.

Outline your lips with a lip pencil, as you would normally. For that ombré effect, use the lip liner to fill in the corners of your lips slightly, but don't take the liner onto the central part of the lips, just keep it in the corners and around the very edge of your lips. If you want to make your lips look fuller, you could slightly overdraw your lips based on your personal preferences.

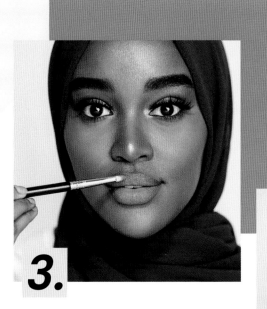

tip

The key to a perfect ombre is tone. Make sure you stick with a bold colour for the outline and a pale tone for the centre.

3.

It is now time to apply your lipstick and see the magic happen right before your eyes. Take a lipstick in a colour that is a few shades lighter than your chosen lip liner, and apply it to the middle part of your lips using a lip brush. You can gently press your lips together but avoid rubbing them over each other as you don't want to blend the two colours in that way.

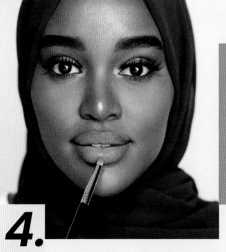

4.

Take a lip smudger brush and begin to blend the lipstick gradually onto your lip liner to create a perfect graduating effect. Don't be scared to go in with more colour if you need to, just make sure that you keep blending so there are no harsh lines. Once you are happy with the blend and the look of your lipstick, take a little concealer in your skin shade on the back of a small angled brush and use this to clean up the edges of your lipstick to give it a nice and tidy finish.

For easy ombré lips, you will need...

- concealer
- lip liner
- lipstick
- lip smudger brush

10\ Natural look

We all want that minimal look sometimes. The "no make-up make-up" look has been a favourite of celebrities for years and is still a top hit for everyone today. As much as I enjoy going full-face glam, there is nothing I love more than looking as natural and flawless as possible with not too much effort. Here is how you can nail this look by focusing on skin prepping and using fewer products.

I always remind myself that the ultimate key to a flawless base is skincare. I ensure that I deep cleanse my skin every night so that it is fresh in the morning for when I apply my make-up. When it comes to the "no make-up" look, I prefer using an oil-based moisturizer as it gives me that dewy effect that I am aiming for. (I remember using coconut oil until the lovely Iyecha who did my facials explained how bad this was for my pores. I had never really thought about it, but she reminded me that natural coconut oil is a thick paste until it melts in the sun or in your hand and becomes an oily liquid. So I had to think about how this would look on my skin once it sets and, long story short, Iyecha saved my pores.) I recommend using a face oil chosen to suit your skin type. If you are naturally quite oily, then you are one step ahead – lucky you!

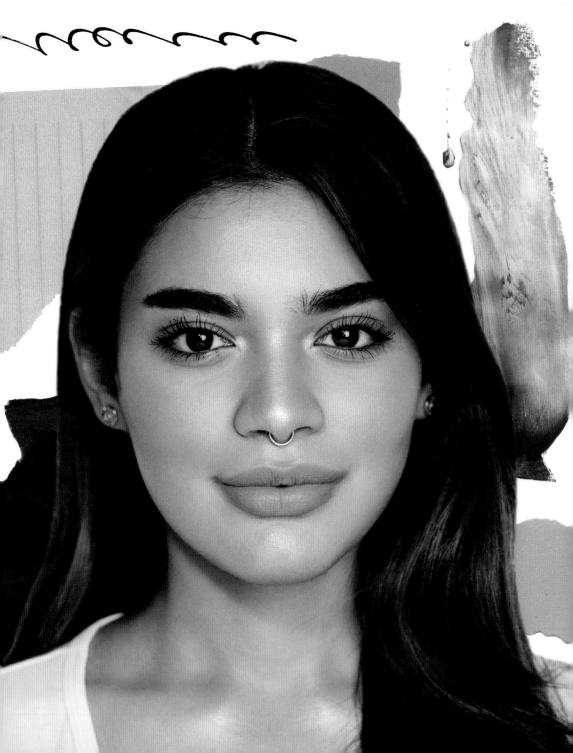

HOW TO...get the ideal "no make-up" look

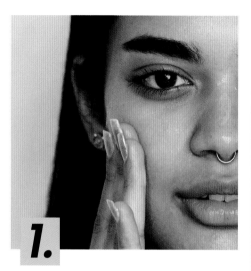

1.

I prep my face using a creamy-textured primer that will help to hydrate my skin and give me that fresh finish. If you want a glow, use an illuminating primer to give you a perfect iridescent finish.

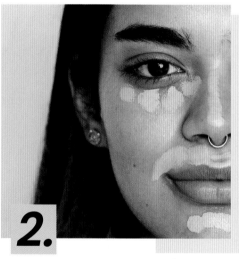

2.

The important thing in this "no make-up make-up" look is to replace your foundation with concealer. Using a concealer that is the closest match to your skin, apply a little under your eyes and on any areas where you have discolouration or dark spots. I like to focus my concealer around my mouth, as that is where I have the most hyperpigmentation. If you want a look that is a little brighter, go ahead and use a slightly lighter concealer underneath your eyes to give you that fresh, bright-eyed look.

insta-glam

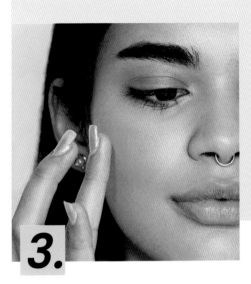

3.

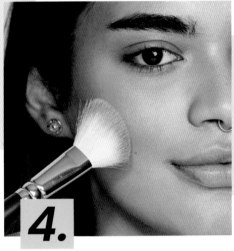

4.

You may be surprised to hear that as natural as these celebrities look, they are still using the same products as they would for a full-glam face, but in smaller quantities and with a softer touch. It is essential to add colour and definition to your face using a bronzer and a blush. The bronzer will help to lightly sculpt your face, so focus this on areas such as underneath your cheekbones and your jawline, and use the blusher lightly to add a flush of colour to your skin without it looking too overpowering.

It is completely okay to still glow from space in a "no make-up make-up" look. This is the fun part, where you add a shimmery gold or a pearly silver highlighter to your face, depending on your complexion and what works for you. I like to add this highlighter to the highest point of my cheekbones, on the tip of my nose and underneath my brow bones using a fan brush, because these are the areas that sunlight naturally hits. I then go in with a damp beauty sponge to blend this out until I am happy with how it is looking. I find that using a damp beauty sponge to blend my highlighter really helps to work it into my skin so that there are no harsh lines and I have that dewy complexion that I really love for this look.

tip

This is the look you have seen on your favourite celebrities. Don't be afraid to wear several products, it's all in the blending for this look. A no make-up look is perfect for those lazy days!

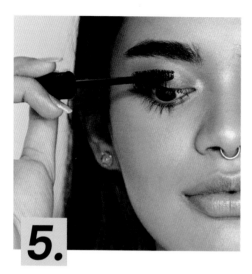

5.

Moving on to my eyes, I curl my lashes and then lightly apply mascara on both my upper and lower lashes. I use only a small amount of mascara so that my lashes look as natural as possible and with no risk of clumping.

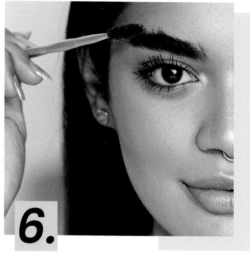

6.

I brush through my eyebrows using a spoolie and fill in any gaps that are visible using a pencil with hair-like strokes in the direction of growth.

Hani says

There really is no prescribed amount of make-up you need to be using or, indeed, anything you can't use for this look, so have fun with it. The only rule is to ensure everything is as blended out as possible so that it looks just like your skin. When you have finished, your face will be screaming, "I woke up like this!"

7.

I finish with a lightly tinted lip gloss to give my lips some moisture and a little colour.
I find that a lip gloss on its own is perfect for this look as it really complements the glow. You can build up the intensity of colour by using a lip liner underneath the gloss, depending on how subtle you want the finished effect to be.

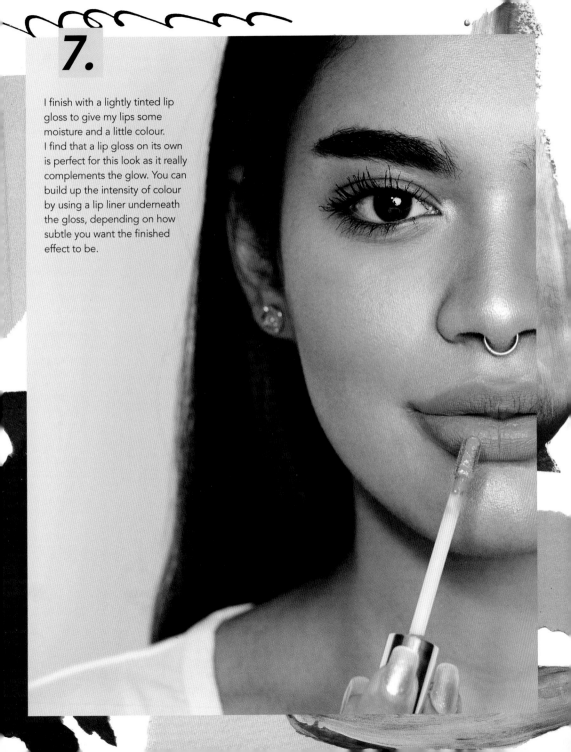

For the natural look, you will need...

- primer
- concealer
- bronzer
- blusher
- highlighter
- mascara
- eyebrow gel
- lip gloss

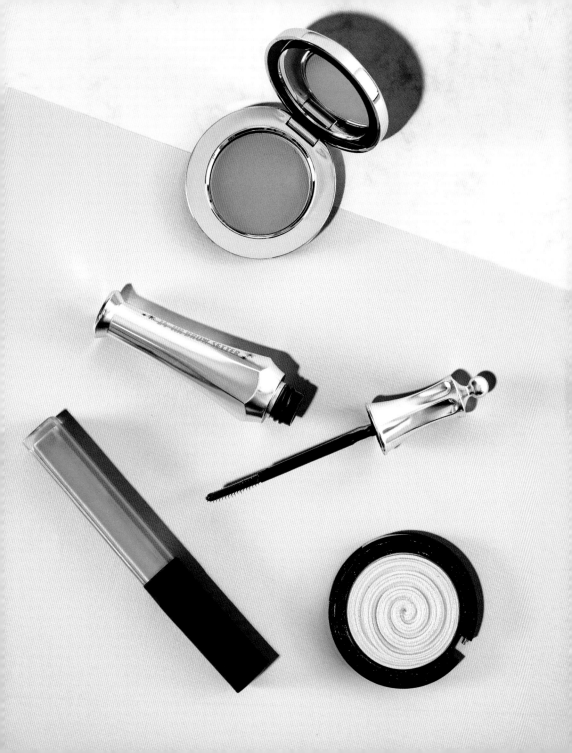

11 \ *First date – a subtle but pretty look*

If you are about to go on your first date, you will most likely spend the whole week beforehand sending your friends pictures of all the possible different hairstyles, outfits and make-up for the date. A first date is all about feeling confident, bringing the best version of yourself to the table, and feeling on top form mentally, physically and spiritually. You may not know exactly what to wear, but try to figure out a casual and cute outfit that you feel comfortable in.

Date night make-up is definitely a bit more stressful, so here are some suggestions for how to make yourself date-ready using a few different techniques. From bold statement lips and flirty eyes to the classic feline flick, here is how to get first-date ready.

tip

Remember to relax and just enjoy the moment, don't overstress because no amount of make-up will conceal your lack of confidence. Bring the best version of yourself, you got this!

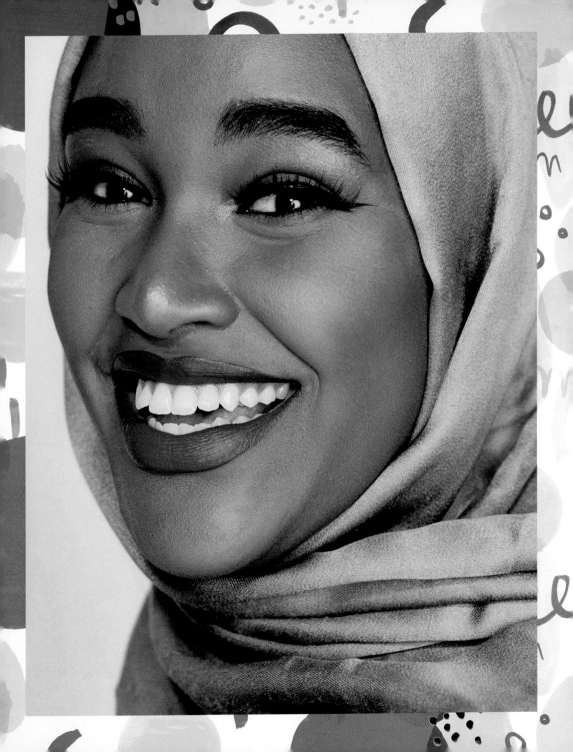

Look 1
Feline flick

Feeling comfortable and still "you" is so important when it comes to dating, especially on the first date. You might not want to go full-on glam because you probably want to look like you have made an effort without looking too over-the-top, and finding the right balance can be super-frustrating. If you are not sure what to do with your make-up, why not try a simple base and a nude lip with a feline flick? Since you will hopefully be making a lot of eye contact, you can really give your date that smouldering stare and look hypnotising as you do so. This is a really sultry and subtle alternative to a smoky eye but still has the same impact. It is completely up to you how thin or thick you make the flick, but I suggest staying on the subtle side because you don't want to look too glam for a first date. For how to do a feline flick, see Perfect Winged Liner on page 48 and see Natural Nude Lip on page 54.

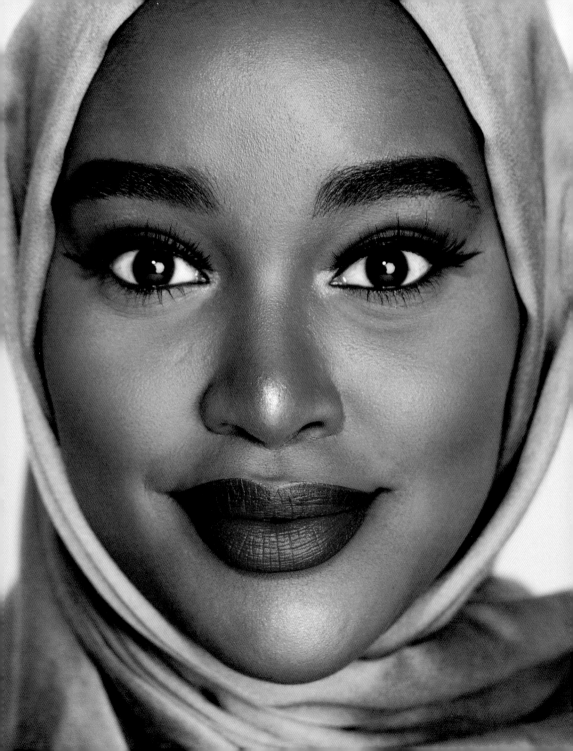

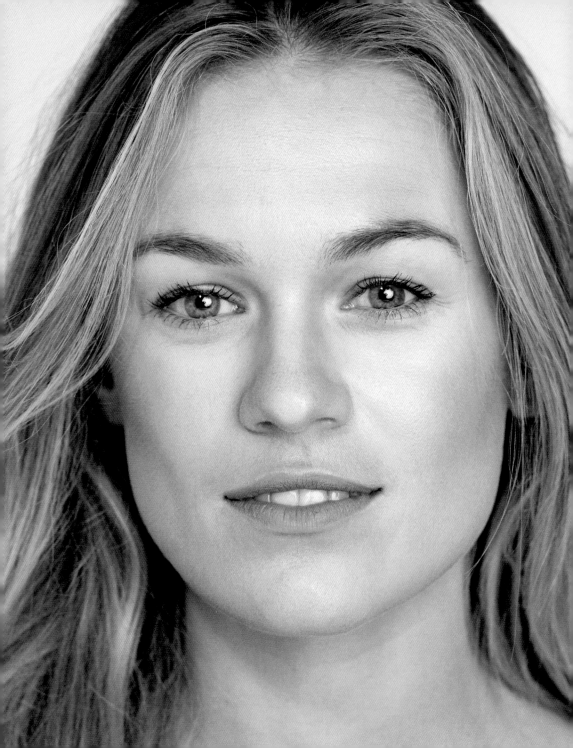

Look 2
I woke up like this

Sometimes we forget that our date might not
even notice whether we have make-up on or not,
and a lot of the time they aren't even bothered
about it. Less can often be more, so tone down
everything and wear a light foundation with a
little bronzer and blush, some mascara and a
touch of pink on your lips. I recommend a lip tint
so that your lips still have that hint of pink by the
end of the date. This is a simple way to nail the
perfect first date look.

Look 3
Statement red lip

Red lips are a total classic! If your goal is to get your date's heart racing, then this is the look for you. Make sure you line your lips first and apply a matte red shade of your choice, paired with really natural eyes and a dewy complexion. This is a perfect first date combination for a sophisticated and bold look (see page 58).

Try not to worry too much about your make-up, outfit or hair for your first date. Focus on glowing from within. Of course, looking the part will make you feel at the top of your game, but confidence is the best thing you could possibly wear. Be comfortable in your own skin and know that you look amazing regardless of how you do your make-up or what you wear, and that confidence will speak volumes for you.

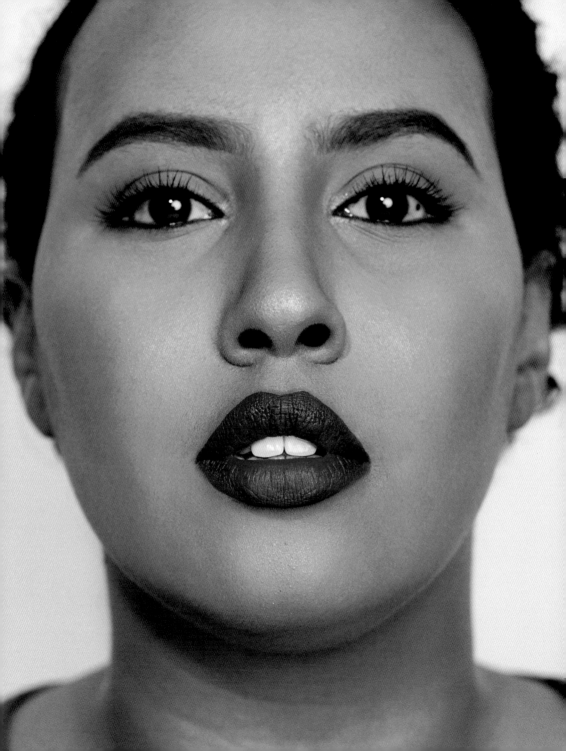

12 \ *Prom night*

If you are reading this, then it must almost be that special moment you have been waiting for since you started school. I know how excited you must be, but I can imagine you are also feeling slightly nervous and worried about what to wear and, more importantly, what make-up look to go for. Planning your prom look can be a little stressful because it is probably the second most important occasion of your life – your wedding being the first. So let's get you prom ready with these five special looks that are bound to make it a night you will remember, with photos you will DEFINITELY want to take!

Remember to dance the night away and don't spend forever worrying about your make-up and your dress. Have a good time and create beautiful memories. Well done on making it to prom!

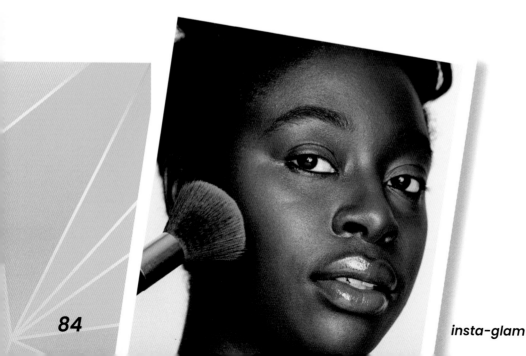

insta-glam

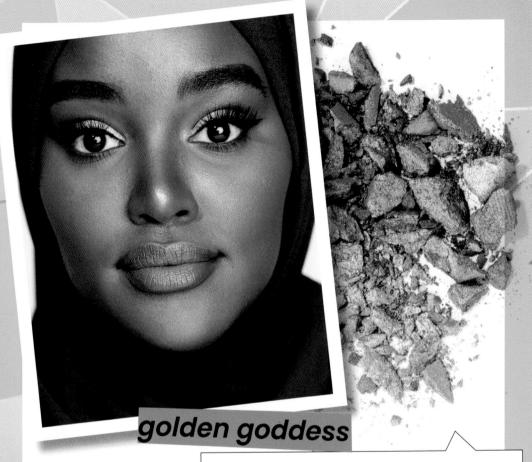

golden goddess

Look 1

This is a classic look fit for a prom queen, and the perfect balance between super-glam and natural. The Golden Goddess is all about the eyes and skin, with gold shimmery eyeshadow that is blended out for a smoky effect, and sultry fluffy lashes that keep the focus on the eyes and your glowing face. In terms of blush and lipstick, go for quite a neutral tone that complements the golden hues of your eye make-up and your highlighter.

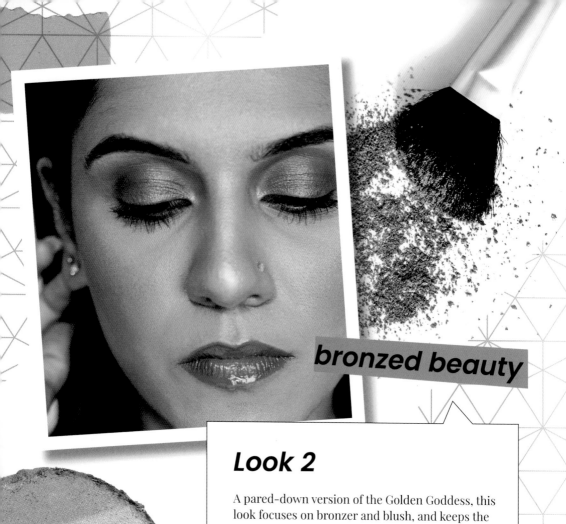

bronzed beauty

Look 2

A pared-down version of the Golden Goddess, this
look focuses on bronzer and blush, and keeps the
eyes a little more neutral with bronze and brown
tones. I suggest completing this look with a nude
glossy lip with a hint of brown for that "I've just
come back from holiday with a tan" flavour, even
when you haven't. The key product for the Bronzed
Beauty is bronzer, so make sure you find the
perfect tone to suit your complexion and then you
can wing everything else, because the focus will be
on your chiselled cheekbones and defined jawline.

Look 3

Peachy make-up has been a craze everywhere for a really long time now. It used to be all about the dark smoky eye for prom, but is peach the new black? This look can be for anyone who wants to go glam with a summery vibe. You could either stick to a peachy blush and peachy lipstick with some false lashes and a little champagne-toned eyeshadow, or go the extra mile with eyeshadow in peachy pink tones mixed with a champagne gold on the tear ducts for a little pop of colour. I always find that peachy blusher is perfect for giving you that fresh, newborn baby look, and is soft and subtle enough for day and night.

peachy queen

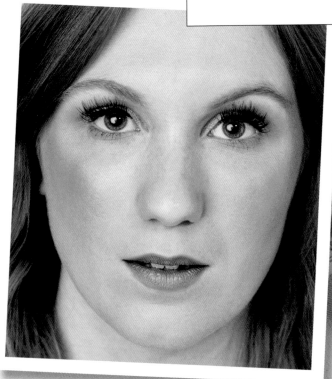

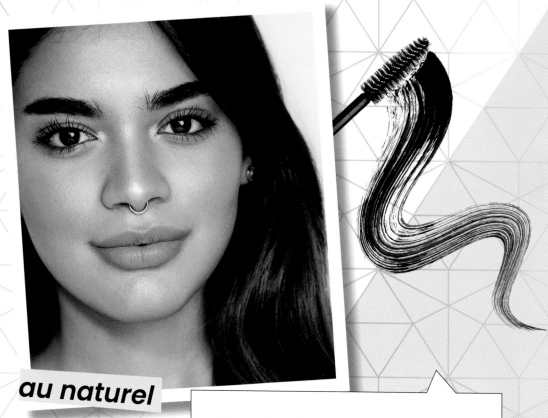

au naturel

Look 4

This look is fit for the natural princess who doesn't want to do too much, and that is completely okay. For a little natural glam, you might want to apply a touch of concealer in your skin shade on any pigmented marks or spots and under your eyes to conceal dark circles. Focus on your mascara, since that will make your eyes pop a little more, and go with a neutral lip gloss in a soft pink. This look will complement pretty much any outfit you choose and your natural beauty will most definitely be shining through.

Look 5

This is all about the pinks. I never used to be one to experiment with pinks especially, but now I am all for it. Have you seen those pink cut creases on Instagram? I used to spend hours staring at them and now I wish I could go back in time and attend prom, just so I can wear this look. It includes a half cut crease with a shimmery pink all over the lid that is deepened with darker tones of pink in the crease. You could either go all out Barbie with a powerful prom-stopping pink lip, or keep it subtle with a more neutral nude. You only get prom once, so live boldly!

hey Barbie

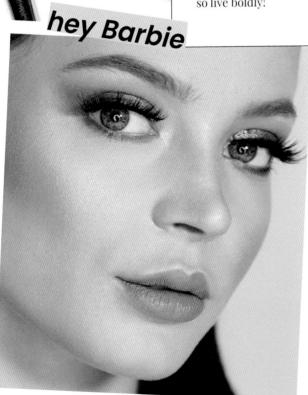

13 \ *Summer festival glam*

Even the cutest outfit on earth isn't enough if your festival make-up isn't Insta-worthy. For me, summer festivals are completely about who can add the most glitter to their face and shoulders, and what the boldest eye and lip colours are. The ideal festival look always seems to pair casual everyday outfits with make-up that walks into the room even before the person does. Here is a guide to how to add little touches to your make-up to take it to the next stage and get festival ready.

Hani says

Festival make-up is all about colours and fun, so be as creative as possible. Use your face as a blank canvas for all your exciting ideas and play with as much colour and glitter as you like. If in doubt, just WING IT, with a coloured liner of course!

insta-glam

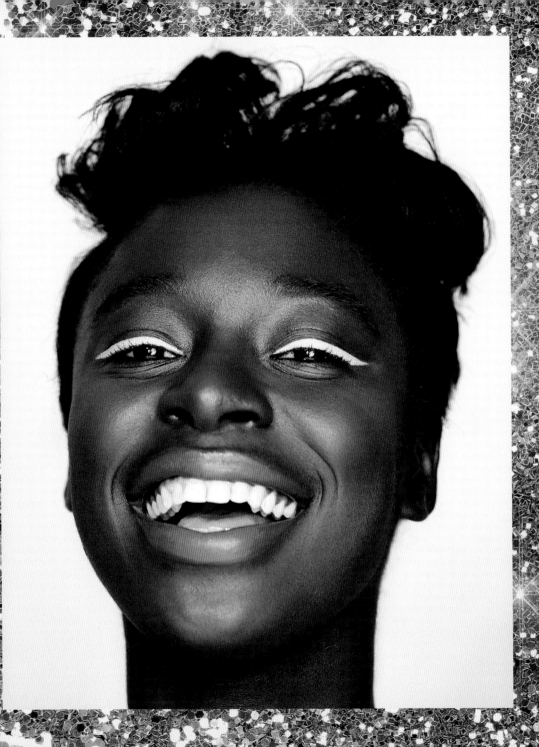

Look 1
Glitter

When in doubt, add some glitter. Apply some on your shoulders and eyelids. There are definitely no rules when it comes to festival make-up, so feel free to even go for the really cool glitter tears look. I always find adding a touch of colourful glitter on the tear duct makes a huge difference and it is super-easy and quick. I have seen so many images of people with glitter on their lips, too; I am not really sure how comfortable that is, but it sure looks worth it!

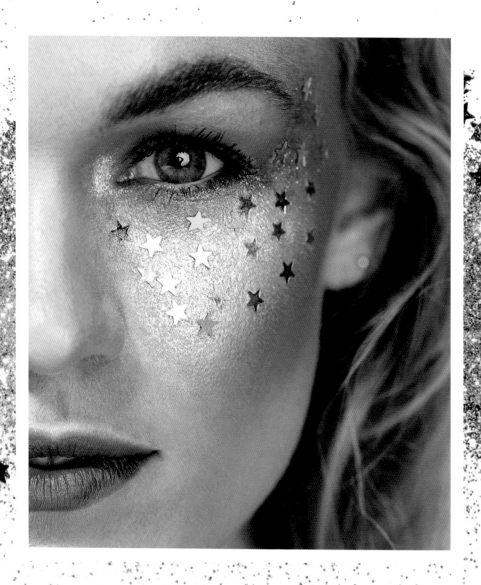

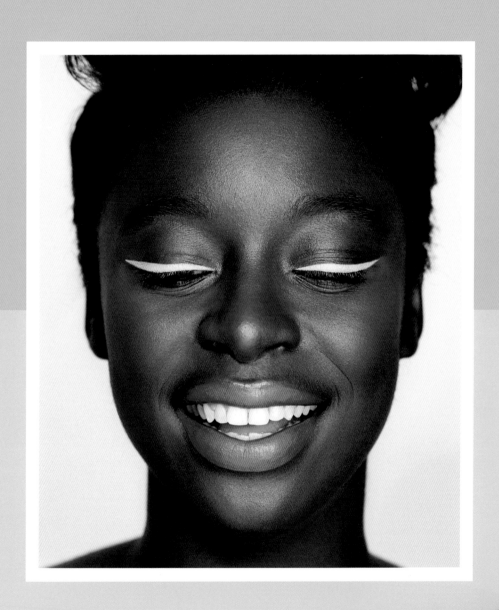

Look 2
Coloured liner

Go bold and experiment with different coloured eyeliners. You may have seen pictures of winged eyeliner in bright yellow and green circulating on social media. Yep, it is as simple as that and so effective; the bright colours automatically make you stand out from the rest of the crowd. If you want to get extra creative, use coloured liquid eyeliner to draw little diamonds or hearts around your eyes or even little dots over your forehead to get that really edgy and cool look.

Look 3
Highlight heaven

Another great way to look festival ready is to highlight. In fact, no summer festival glam is complete without a blinding highlight. Add a touch of loose glitter for extra sparkles on your cheekbones. If you want to stand out a little, coloured highlighter might just do the trick. Lightly dust an iridescent pink or blue highlighter onto the highest point of your cheekbones using a fan brush. This will give you that summer festival glow.

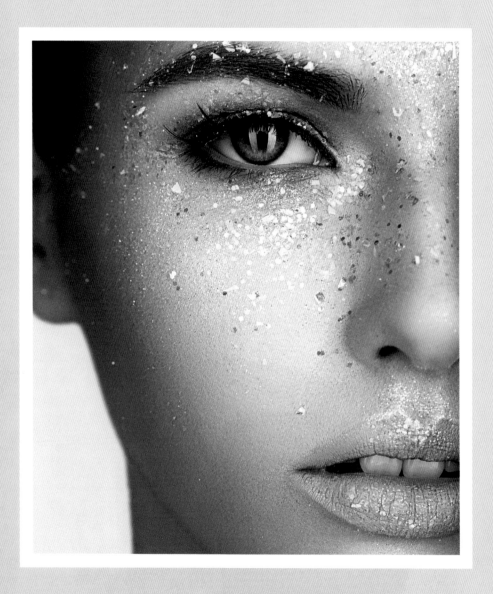

14 \ Festive glam

'Tis the season for glitter and all things red! Even though I don't celebrate Christmas myself, after many years in retail I know how stressful it can be. You already have a lot on your plate worrying about what you will get for everyone's presents and on top of that you have to worry about decorating the tree; but, most importantly, how will you decorate yourself?

Christmas is the perfect excuse for glittery eyes and bold red lips. But that doesn't mean you can't wear the same look at any time of the year, because you most definitely can. I am going to show you how to get the best out of your festive make-up, so grab your glitter and let's get started.

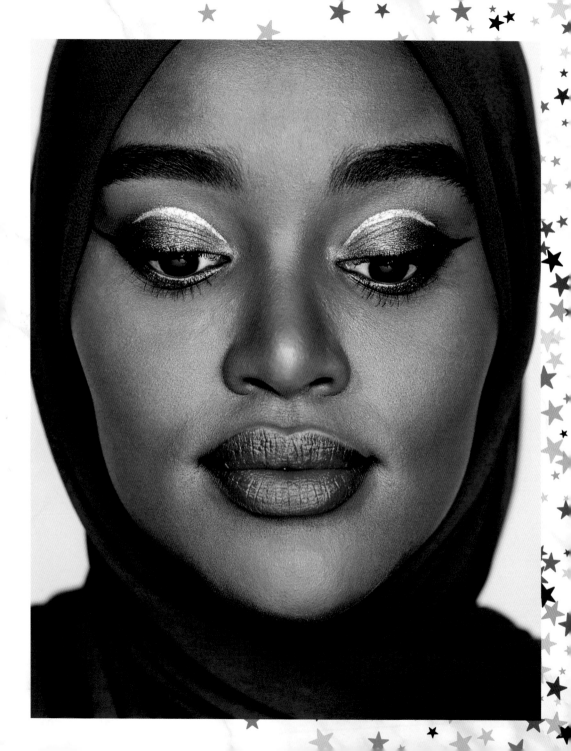

HOW TO...get the festive glitter on

1.

You should begin this look with your eye make-up so that you can easily wipe away any excess glitter fallout before moving on to your face routine. Start by filling in your eyebrows and shaping them to your desired style (see page 34).

2.

Once this is done, you can take a concealer that is a little lighter than your skin and apply it underneath your eyebrows. Blend it down onto your eyelids, to neutralize them and prepare them for the eyeshadows. Finish this step by patting an eyeshadow primer lightly over your eyelids.

insta-glam

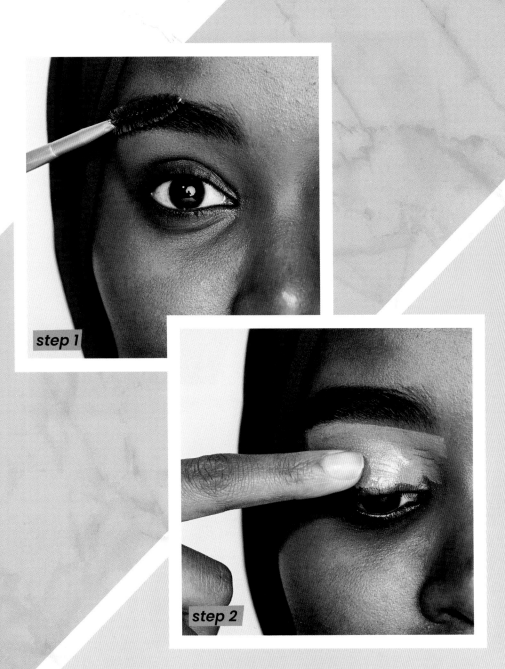

step 1

step 2

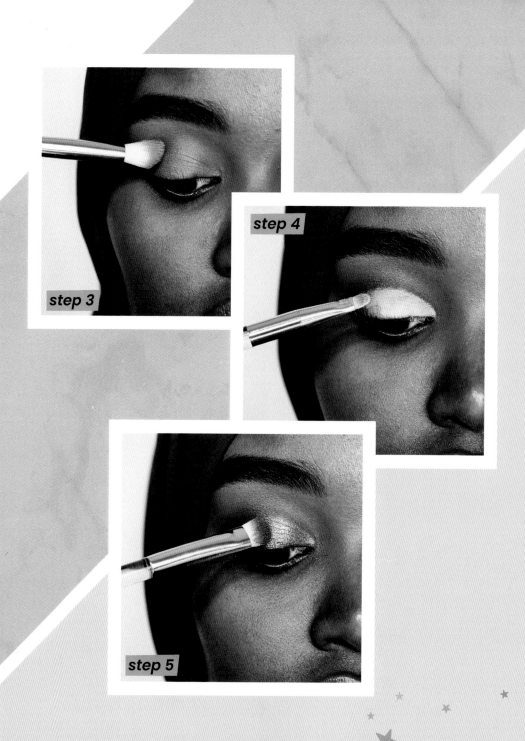

step 3

step 4

step 5

3.

Gently set the concealer and primer on your eyes with a little loose powder to help them stay put. Taking a fluffy eyeshadow brush, swipe a neutral-toned brown or orange eyeshadow into the crease of your eyes and blend it outwards. This will act as your transition colour.

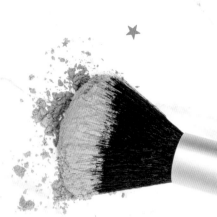

4.

Go in with a deeper colour to build up the intensity of the first, and keep going until you are happy with the depth of colour. Don't forget to keep blending everything together. Using a tinted eye primer or a concealer on a small brush, carve out the shape of your eyelids to give you a blank canvas for the base eyeshadow you are about to apply.

5.

Once you have done this, apply your chosen colour – gold, silver or green – all over your eyelids and blend it out. Bring your glitter out! For loose glitter, I recommend gently applying glitter glue as a base on your eyelids for the glitter to catch on to.

6.

For even more glamour, finish with some winged liner and mascara or even go the extra mile and add your favourite pair of false eyelashes.

7.

Apply a pop of green along your lower lash line to really look like your Christmas tree, and then complete the rest of your make-up. You can either go as minimal as you want with your face and lips or make it a full-glam look based on your personal preference. There really are no rules!

Hani says

Don't stress, everything will be a blast and you have got it all under control. Slay your make-up, take a load of Insta-pictures and maybe even a selfie with your twin, the Christmas tree.

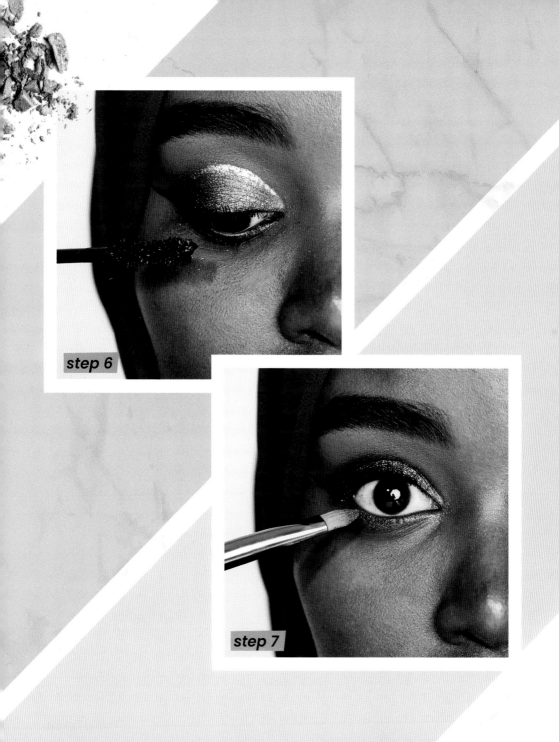

step 6

step 7

For the festive glam look, you will need...

- eyebrow gel
- concealer
- eyeshadow primer
- neutral eyeshadow
- metallic eyeshadow
- glitter glue
- loose glitter
- eyeliner
- mascara
- red lipstick

15 \

The perfect selfie

Insta-glam would not be complete without advice on taking the best selfie. When you are trying to capture that perfect selfie for Instagram, there are so many things to take into account: lighting, angles and background. Here is a guide to getting the selfie that will leave everyone thinking, WHO IS THAT?!

Lighting

When it comes to lighting, sunlight is your best friend. In the morning, if the sun is shining brightly, it can be difficult to take a perfect selfie without your eyes squinting, so the best time to take it is an hour or so before sunset when the sun has become less harsh and more golden. They don't call this time the "golden hour" without reason. If you are sensitive to the sun and still struggling to take the picture with your eyes open, try keeping your eyes closed and opening them just before you press the shutter.

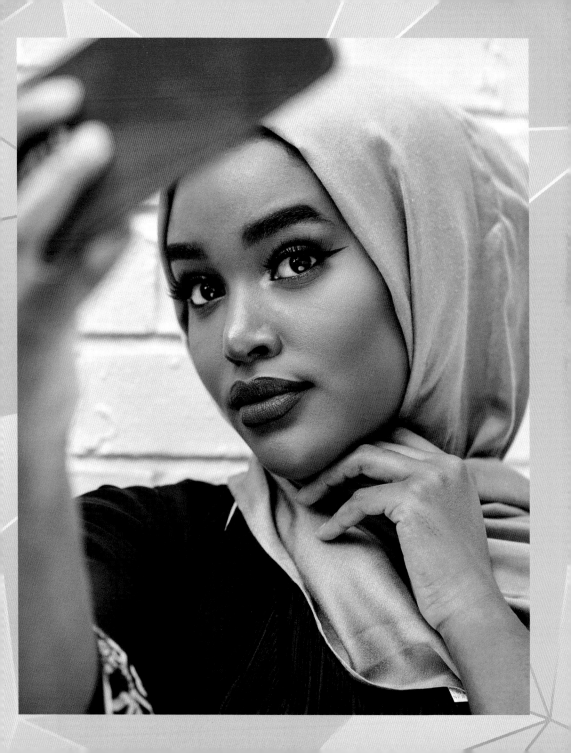

Background

I am that girl who will take a picture anywhere – in front of a bus stop, at a station, with a couple arguing behind me – but when it comes to looking at which picture to upload to Instagram, I don't have many options. This means I really should take my background into account as well. I see a lot of pictures on Instagram and in my head I think: lighting, YES; angle, YES; background, YES!

These are the most important things to consider when taking your selfies. Every time, aim to take pictures that are so neat they won't require much editing. I always think it is better to avoid overediting (especially when it comes to pictures of your make-up) because when you airbrush your skin it takes away that lovely skin texture. There is nothing wrong with editing your images per se, because you should always want to portray the best version of yourself, but just keep in mind that you don't need to because you are amazing, and you can now master how to take amazing pictures.

Angles

It is so important to know your angles. Everyone has a good side, a side that they like more than the other. Some people are extremely lucky and love both sides, but for most of us it is either one or the other. I always prefer taking side-angled pictures from my left side because, for some reason, I feel my features look a lot more defined from that angle.

Knowing how to hold your phone or camera at different angles is also a great way to take that stunning selfie. I find low angles really unflattering on myself, and high angles make the ratio between my head and body look slightly alien, but holding my hand out at an angle on a slight slant gives me the perfect selfie. Experiment with different angles and see which you like best. I have seen some amazing shots of people snapped from a low angle that have taken my breath away. I am still hoping and praying that one day I will get a decent low-angle picture.

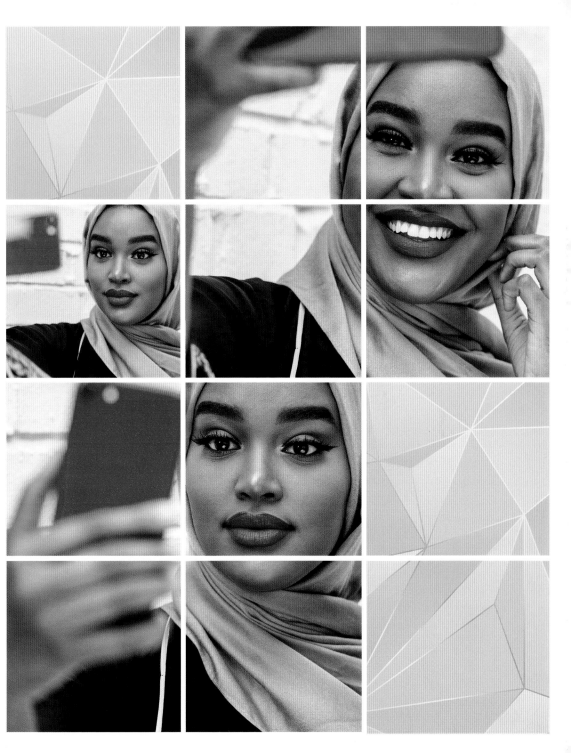

Acknowledgements

Firstly, I am eternally grateful to my parents, as well as my sisters, Farhia and Safiya, for understanding my zombie-like behaviour (lol) and still comforting me in my time of need. I know I may have been a pain this past year but I am glad you have stood by me. I can't put into words how much I appreciate you all, including Grams.

I would like to show my deepest appreciation to my best friends, Marni and Jahanara, for your moral and creative support throughout. It meant the world to me and you girls have been my sanity, thank you so much.

To Abdullahi, who has been by my side from day one! None of this would have been possible without you. You uplifted me and constantly reminded me what a boss I was. I honestly couldn't have chosen a better partner in crime, thank you!

A huge thanks to all the models: Justyna, Samirah, Jahanara, Fayara, Wendy, Vicky, and Harriet. Also, thank you to Rachidah, Sumaya, Khadija and Asha for giving up your time to help me.

Finally, I would like to express my gratitude to the lovely Kyle Books team who have turned my vision into reality and for this amazing experience of publishing my first ever book! Special thanks to Vicky, my ever-patient editor, Nikki, the designer and the wonderful photographer Claire for capturing all the beautiful images.

I love you all very much xxx